Important!
Please copy the Dbook file "Dbook Nikon D80.pdf" to your computer's hard disk and open it from there.
Do not open the Dbook file directly from the CD!

CD drives are too slow to cope with the large size of the Dbook file. If you open your Dbook directly from the CD, its performance will be extremely poor.

Authors:
Helmut Kraus, Düsseldorf, Germany, helmut.kraus@exclam.de
Rudolf Krahm, Troisdorf, Germany, rudolf.krahm@exclam.de
Rainer Dorau, Bad Homburg, Germany, rainer.dorau@exclam.de

www.exclam.de

Editor: Gerhard Rossbach
Translation: Jeremy Cloot
Copyeditor: Lisa Danhi
Layout and Type: Almute Kraus, Rainer Dorau
Cover Design: Helmut Kraus, www.exclam.de
Printer: Friesens Corporation, Altona, Canada
Printed in Canada

ISBN 978-1-933952-15-4

1st Edition
© 2008 by Rocky Nook Inc.
26 West Mission Street Ste 3
Santa Barbara, CA 93101
www.rockynook.com

First published under the title "Das dbook zur Nikon D80"
© dpunkt.verlag GmbH, Heidelberg, Germany

Library of Congress catalog application submitted

Distributed by O'Reilly Media
1005 Gravenstein Highway North
Sebastopol, CA 95472

All product names and services identified throughout this book are trademarks or registered trademarks of their respective companies. They are used throughout this book in editorial fashion only and for the benefit of such companies. No such uses, or the use of any trade name, is intended to convey endorsement or other affiliation with the book.
No part of the material protected by this copyright notice may be reproduced or utilized in any form, electronic or mechanical, including photocopying, recording, or by any information storage and retrieval system, without written permission of the copyright owner.
While reasonable care has been exercised in the preparation of this book, the publisher and authors assume no responsibility for errors or omissions, or for damages resulting from the use of the information contained herein

This book is printed on acid-free paper.

Dear reader,

This **Dbook** is an Adobe Acrobat-based information medium that combines all the advantages of a printed book with those of the new multimedia world. The subject of digital photography is especially well suited to display on a computer screen, where the image quality of modern monitors can be used to its best advantage. The technical limitations of the offset printing process prevent the illustration of the same depth of color and detail that digital photos are capable of producing.

A **Dbook** has other advantages too: its contents are enhanced with multi-media functionalities that are not available to the reader of a conventional book. Especially applicable to its highly graphical content, this **Dbook** user-interaction represents an essential added value compared to a one-dimensional printed book. For example, before-and-after image samples in this **Dbook** are layered on top of each other instead of being printed statically next to each other. This digital option illustrates to the reader more clearly the differences between each shot and the camera settings that created them.

Additionally, **Dbooks** are designed with optimum computer-screen readability in mind. One convenient **Dbook** feature lets you jump directly to the page of your choice via links in the index or the contents section—a function that you are sure to have wished for now and again while reading printed books. The toolbar at the bottom of each page contains all the options you need to navigate through your **Dbook** and to optimize page display. If you want to print individual pages, you can access the print dialog with a single mouse click without leaving full screen display mode.

Rocky Nook **Dbooks** are also accompanied by a handy, robust booklet for use on the road when no computer is available to consult your **Dbook** directly. The booklet is filled with a practical overview of your camera, including its displays and menu options.

We hope that you will soon be enjoying all the advantages of your interactive, digital **Dbook**. Have fun!

www.exclam.de

Düsseldorf, Troisdorf, and Bad Homburg, August 2007

→ This booklet also contains a short introduction to the structure and functionality of your **Dbook.**

Contents

What Info is Where in this Booklet

1

8

6 Your Dbook: An interactive Book in CD Form
The Dbook itself can be found in the Acrobat file on the CD included with this booklet. This first section shows you what a Dbook is and how to use it.

2

4

14 The Camera's Controls
Where to look if you want to know which button or switch does what

22 The D80's Menu Structure
A complete tabular overview of the camera's menu-driven functions

- 22 The Playback Menu ▶
- 24 The Shooting Menu 📷
- 28 The Custom Setting Menu ✎
- 34 The Setup Menu 🔧
- 37 The Retouch Menu
- 38 The PictBridge Menus

39 The D80's Exposure Modes
Exposure modes, and the camera's built-in point-and-shoot modes explained

- 39 P, A, S, and M exposure modes
- 40 Auto mode and the Digital Vari-Programs

17

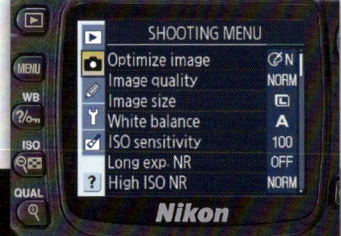

5

2

6

Contents 5

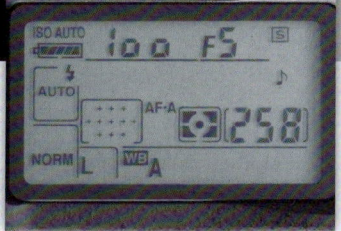

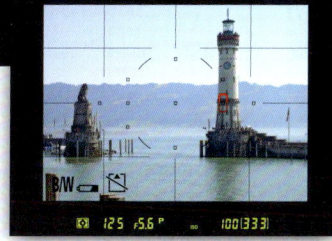

18 **The Control Panel**
A comprehensive table covering all the control panel elements and their various meanings

20 **The Viewfinder Display**
An overview of each viewfinder display element

41 **Installing Adobe Reader**
Adobe Reader is required for you to use the functions in your Dbook properly, and is included on the Dbook CD. This section explains how to install the Reader on your computer and how to configure it to get the most from your Dbook.

Your Dbook: An Interactive Book in CD Form

Your **Dbook** is a new kind of interactive CD-based book, published in the popular, platform-independent PDF format. Your complete Dbook consists of this booklet and the enclosed CD, which contains a free collection of exclusive **Photoshop actions**, as well as the **Dbook PDF file** itself and **Adobe Reader 8** for Windows and Mac OS X. Additionally, your Dbook can also be displayed in Linux or Unix by using an appropriate reader.

This booklet is a useful companion to your **Dbook**, and describes all the most important camera controls and menus, so you are never stuck out in the field without vital camera information even if there is no computer nearby.

The following pages explain the basic structure and functionality of your **Dbook**, which also contains high-quality RGB illustrations and interactive page elements that cannot be effectively shown by even the best printing process.

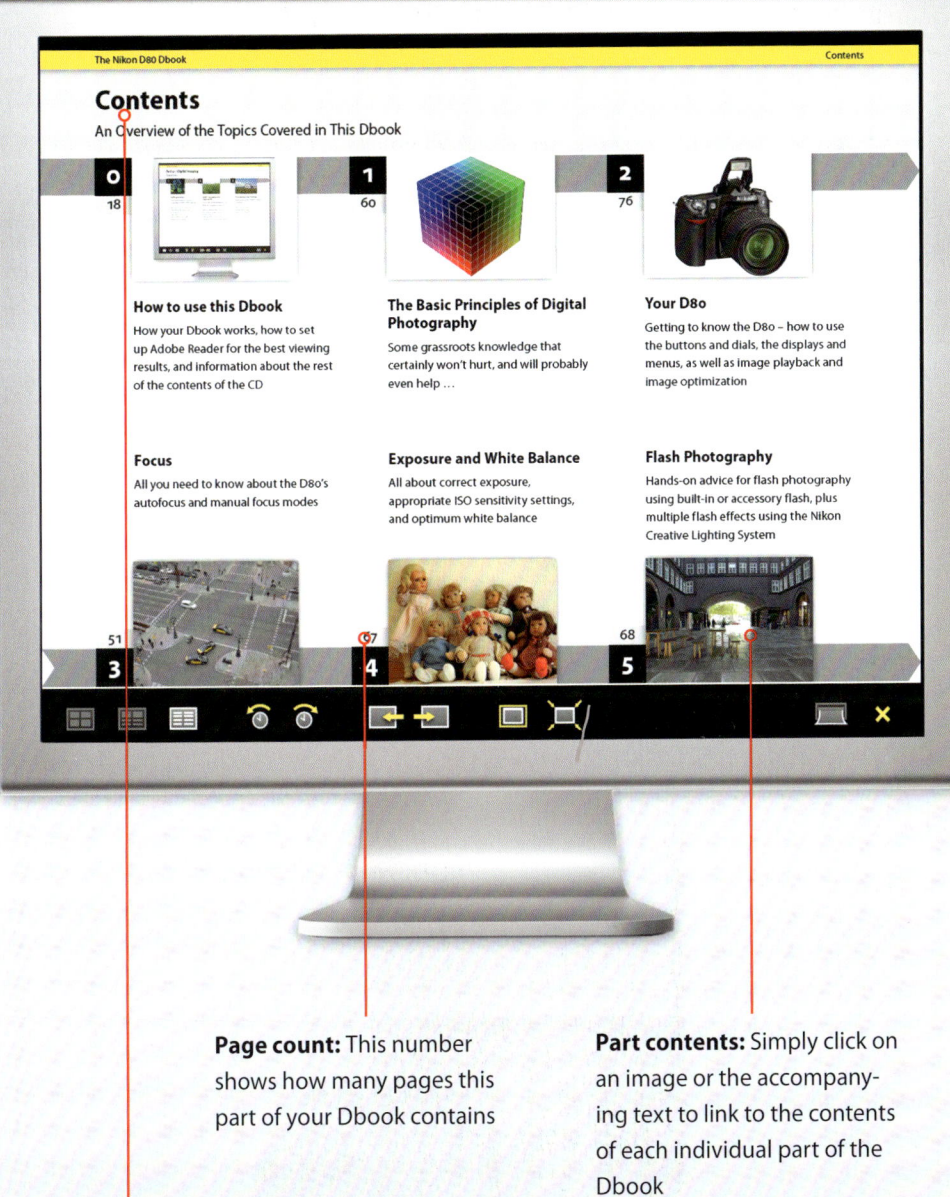

Page count: This number shows how many pages this part of your Dbook contains

Part contents: Simply click on an image or the accompanying text to link to the contents of each individual part of the Dbook

Overview: The contents page offers a complete overview of the topics covered in your Dbook

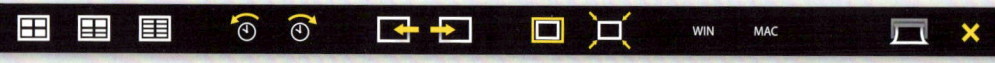

The toolbar at the bottom of the page contains all the tools you need to navigate through your **Dbook** and to optimize page display. If you want to print individual pages, you can access the print dialog with a single mouse click without leaving full screen display mode.

❶ Page display
Your Dbook opens by default in full screen, single page mode at a magnification of 150%. The page display buttons can be used to optimize display quality.

This button activates or deactivates Adobe Full Screen mode.

The "Optimum Size" button allows you to return to the (default) optimum display size if the setting has been intentionally or unintentionally changed.

❷ Page order
The pages of your Dbook are arranged in a fixed order. These buttons allow you to "leaf through" your Dbook page by page, as you would in a printed book.

Takes you to the previous Dbook page

Takes you to the next Dbook page

❸ Viewing history
Adobe Reader records the pages you view and the order in which you view them, including your use of hyperlinks and index entry links. These buttons allow you to retrace your chronological viewing history.

Step Back

Step Forward

About Your Dbook 9

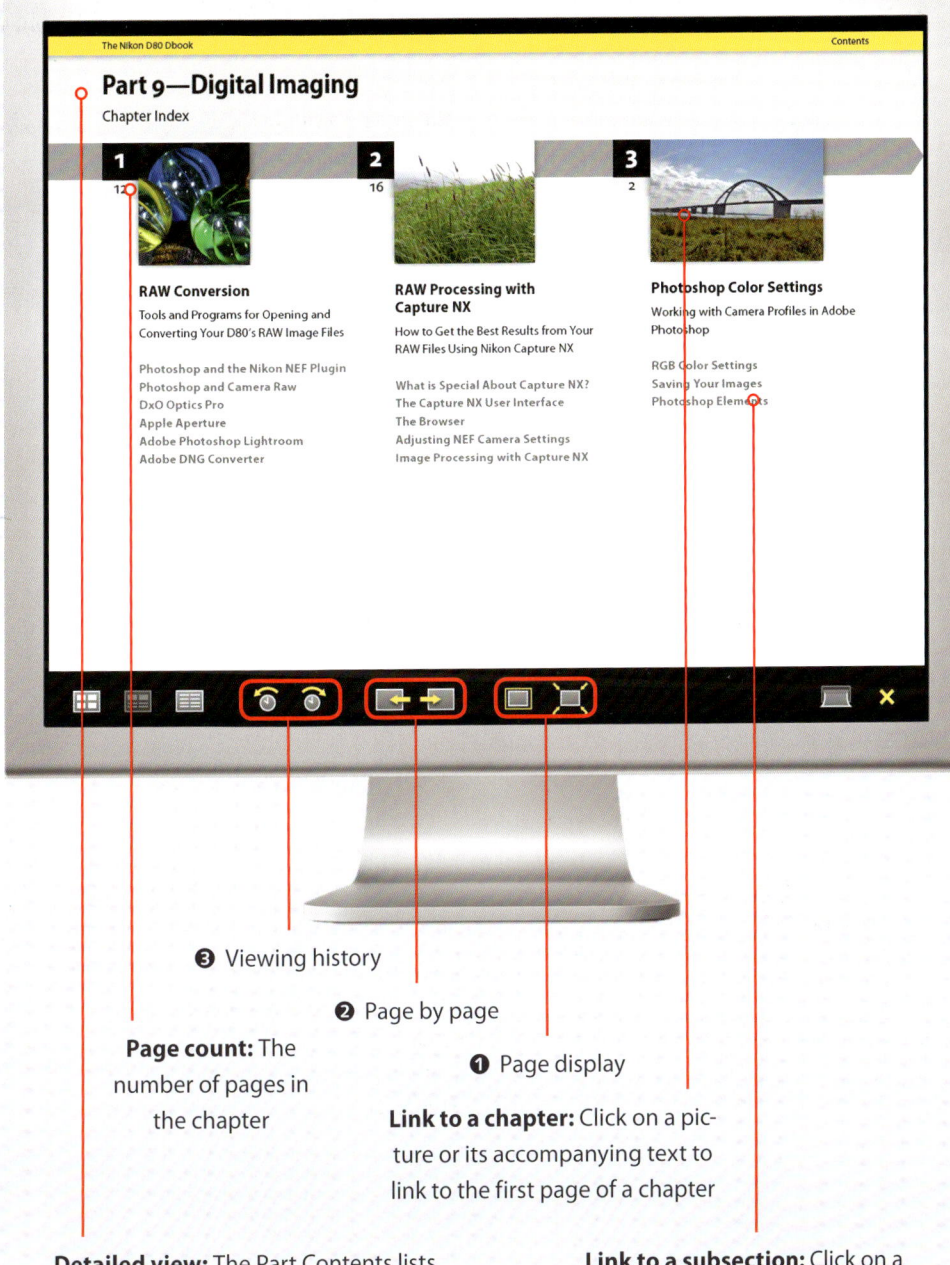

❸ Viewing history

❷ Page by page

Page count: The number of pages in the chapter

❶ Page display

Link to a chapter: Click on a picture or its accompanying text to link to the first page of a chapter

Detailed view: The Part Contents lists all the chapters in the selected part of the Dbook as well as all the subheadings for each chapter

Link to a subsection: Click on a subheading to link directly to a chapter subsection

❹ **Indexes**

The index symbols allow you to link directly to the main contents page or to the interactive index of topic words.

Contents Part Contents Index

❺ **Windows and Mac OS X**

These buttons switch between the buttons and illustrations appropriate to your operating system. The symbols are only visible when different operating system options are available. The status messages "Windows Version Active" and "Mac Version Active" keep you informed of which version is currently displayed.

Show Windows version Show Mac version

Image versions: Every interactive image has its own set of buttons for switching from one version of the image to another. The current image version is indicated by the yellow button highlight.

❻ Print and Exit

The buttons at the right hand end of the Dbook toolbar are for starting a print order or closing your Dbook.
«Print» opens the Adobe Reader print dialog. Dbook pages are optimized for printing in letter format.

Print

Exit

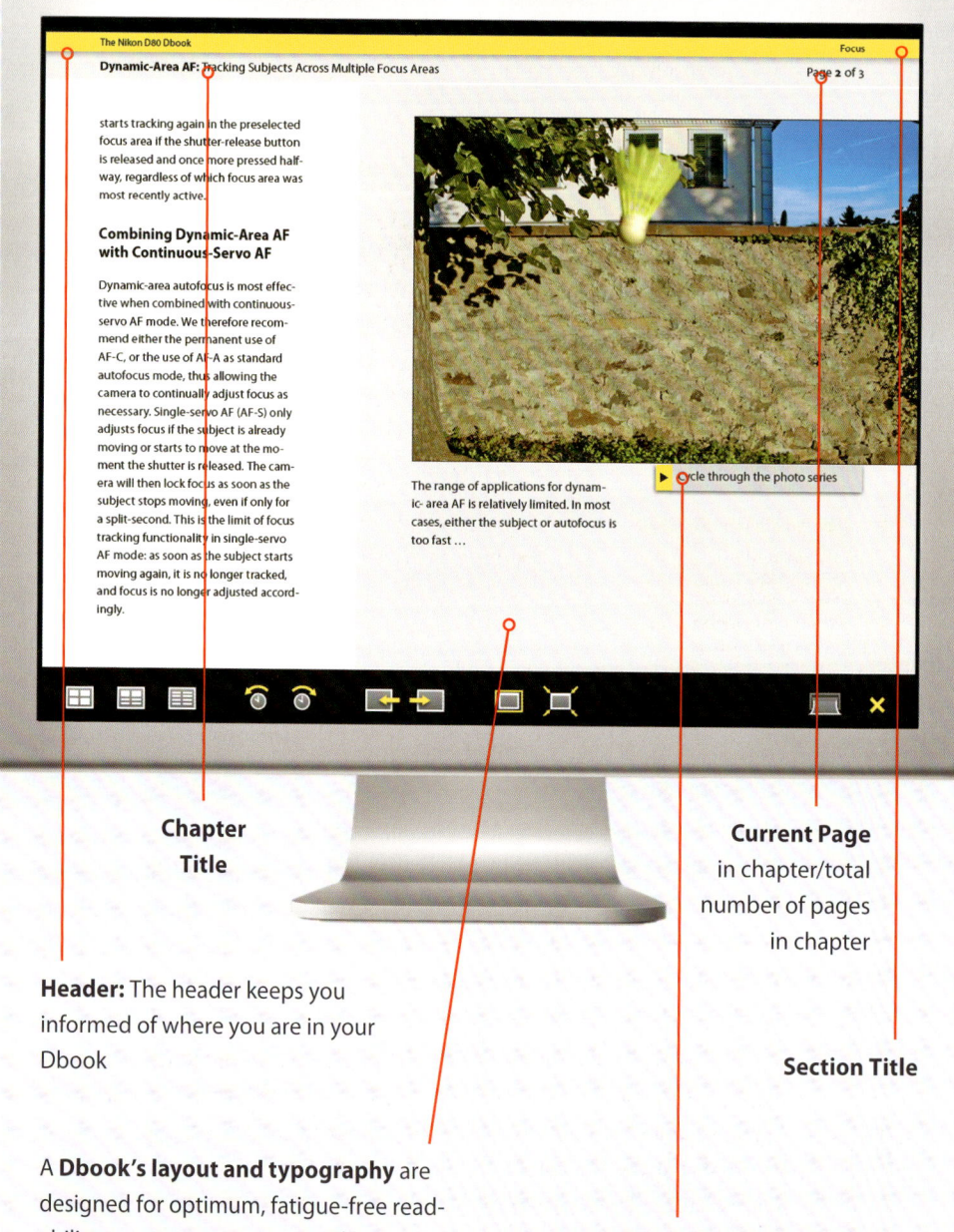

Chapter Title

Current Page in chapter/total number of pages in chapter

Header: The header keeps you informed of where you are in your Dbook

Section Title

A **Dbook's layout and typography** are designed for optimum, fatigue-free readability on a computer screen. The gray highlights differentiate between illustrations or subthemes and the main text.

Image sequences: Image sequences have one single "cycle button." Simply click the button several times to cycle through the sequence.

About Your Dbook 13

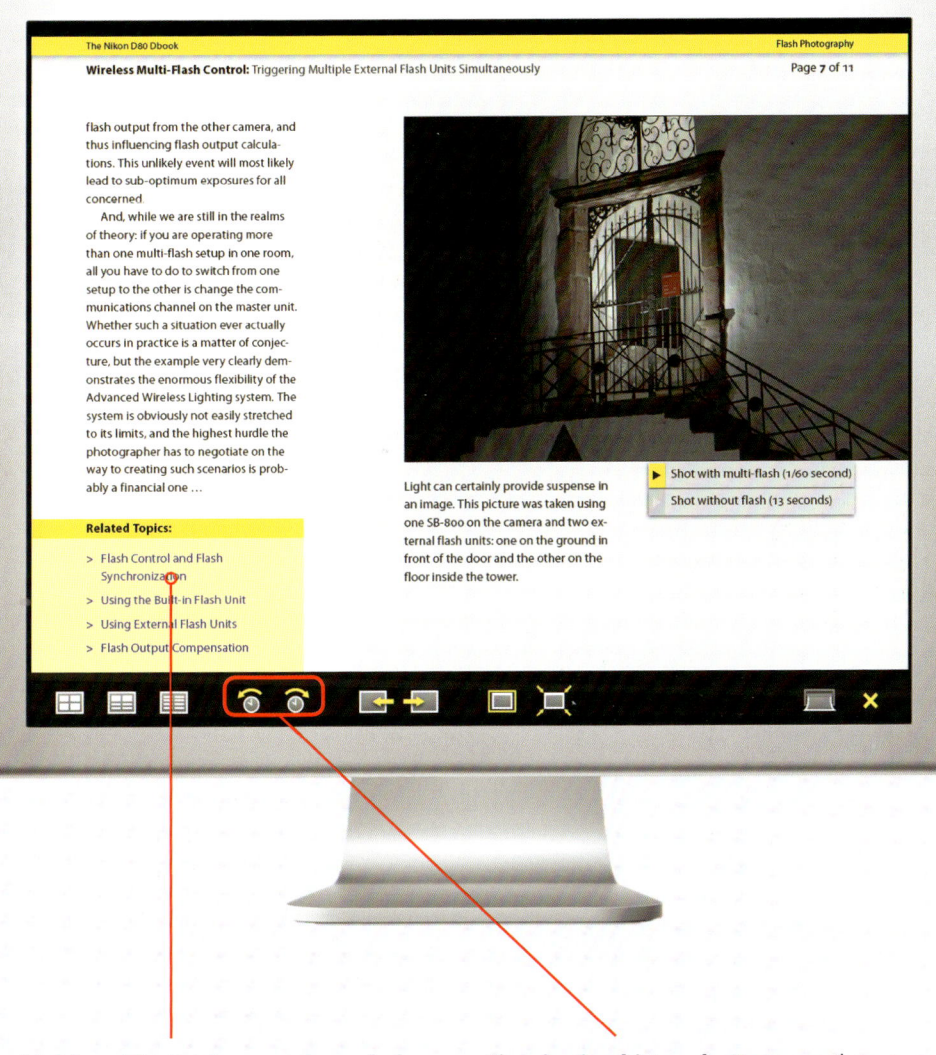

Link box: The link boxes at the end of each chapter contain direct links to other subjects and sections which are directly related to the current chapter. The links enable you to quickly find supplementary information or explanations of technical terms.

The **viewing history buttons** can then retrace for you the chronological steps of your journey through the Dbook pages and direct links.

The Camera's Controls

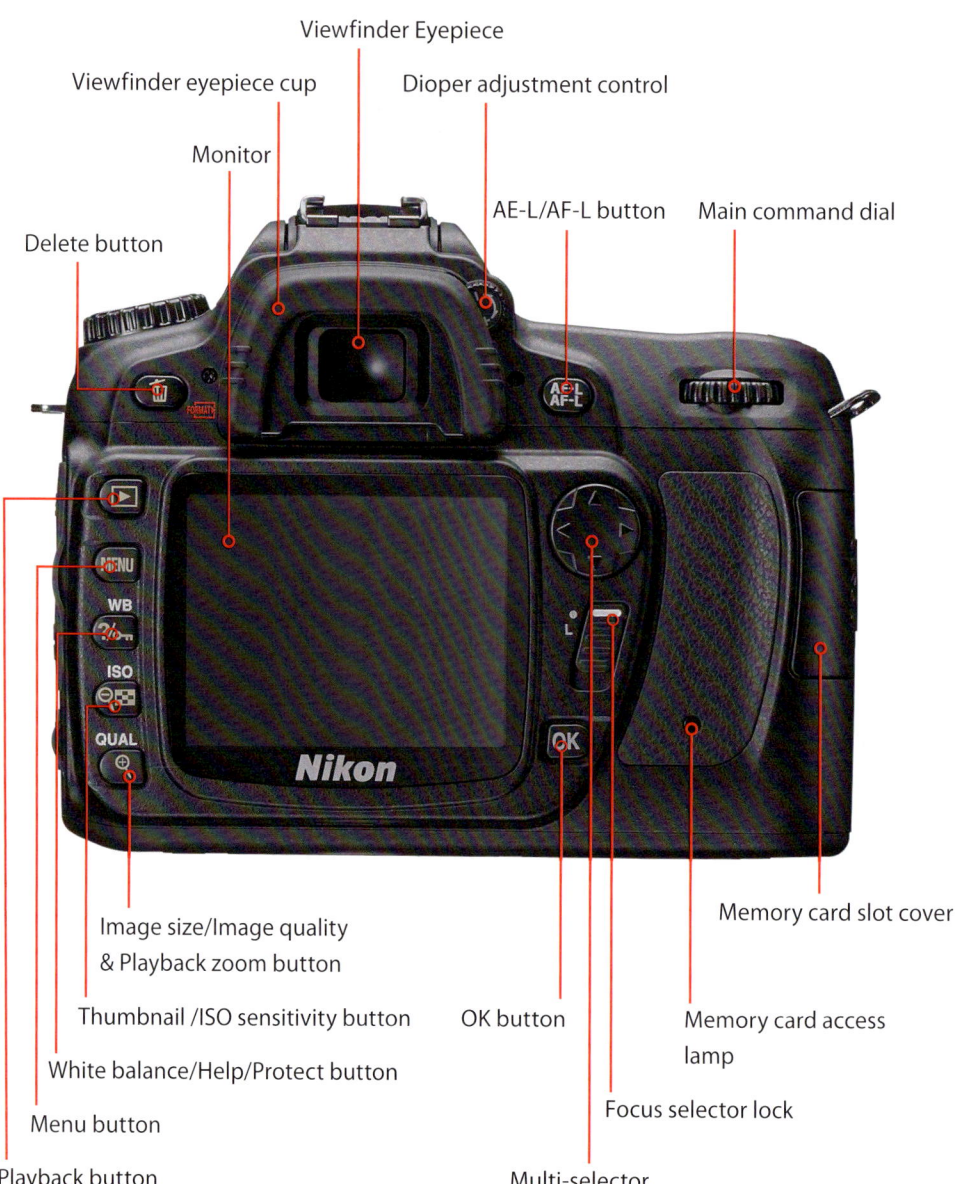

The Camera's Controls 15

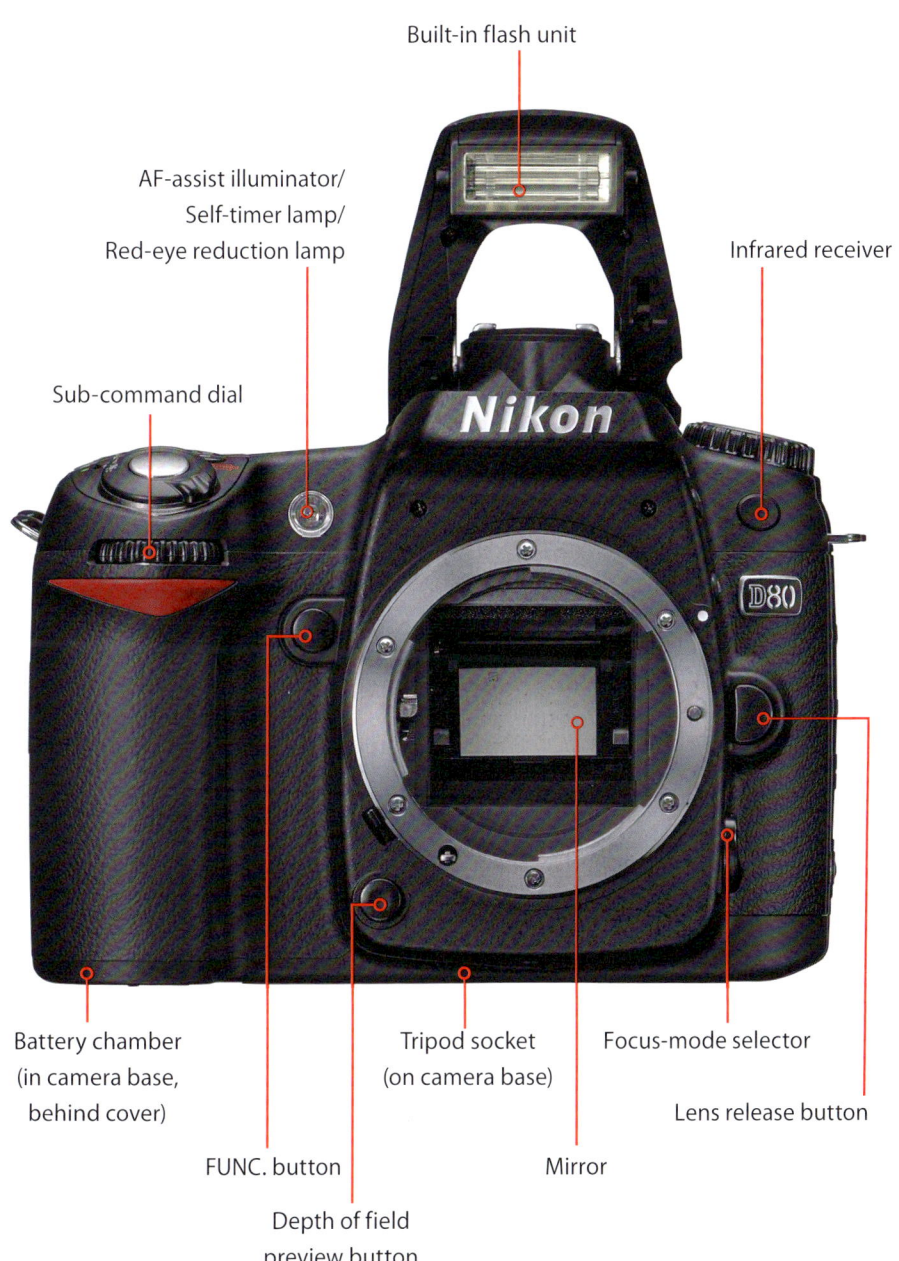

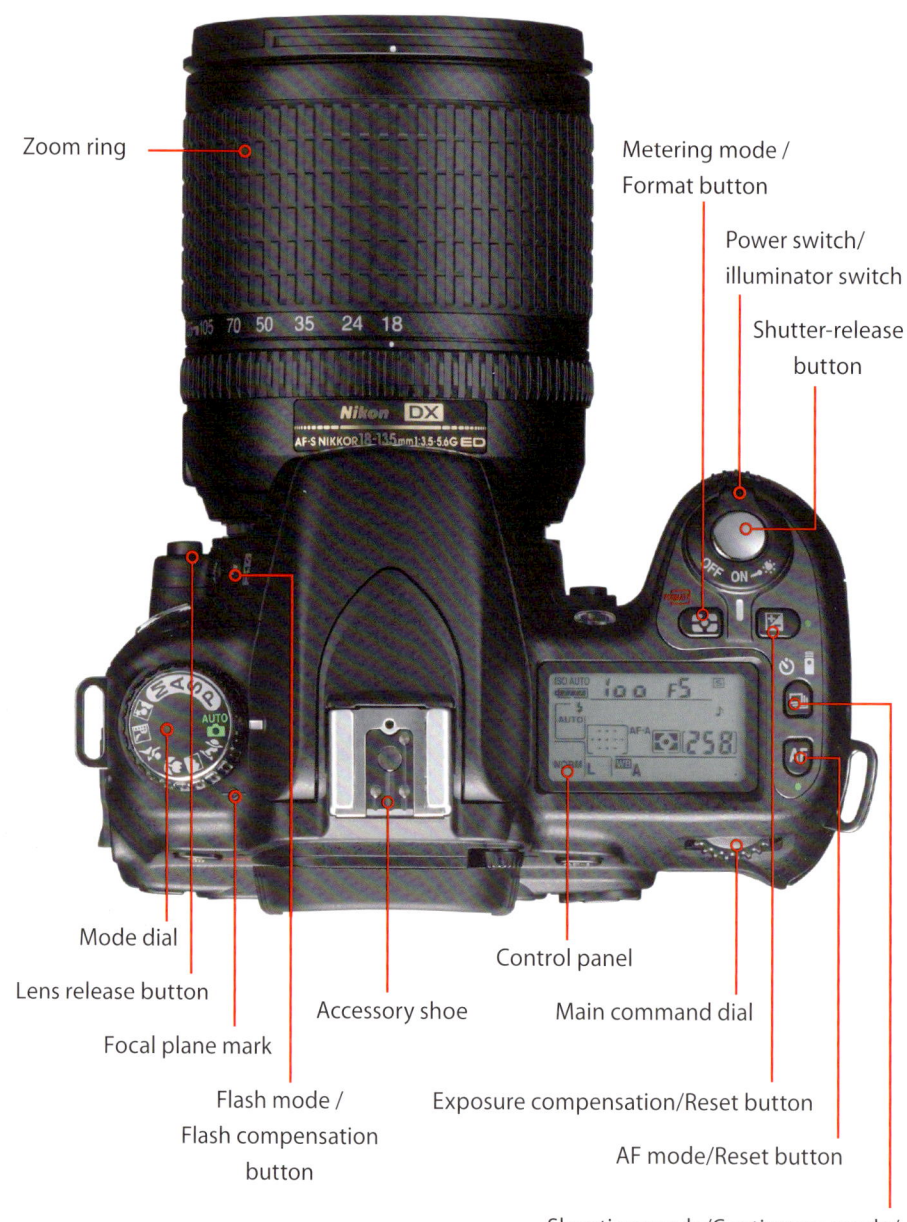

The Camera's Controls 17

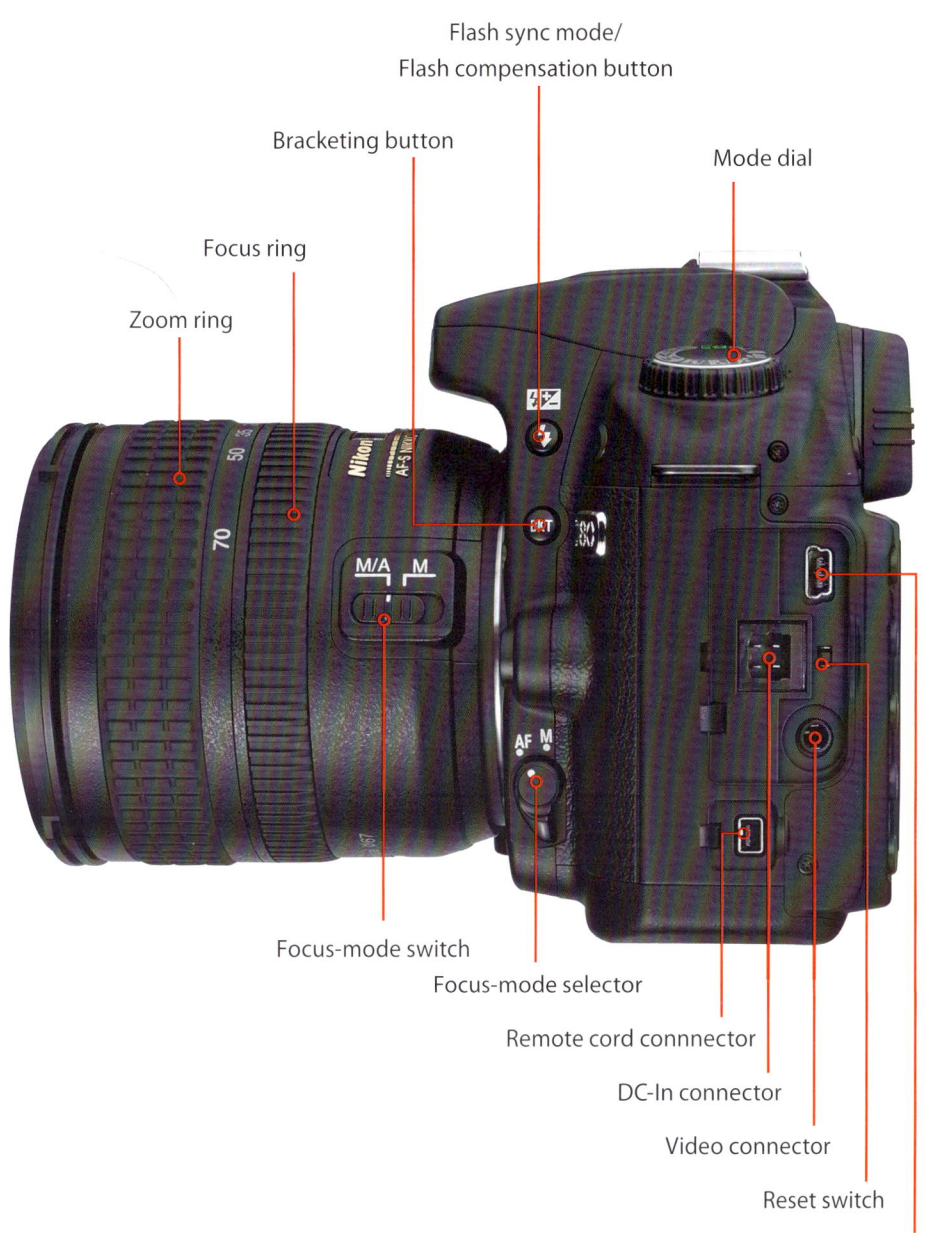

The Control Panel Display

Standard Display Elements

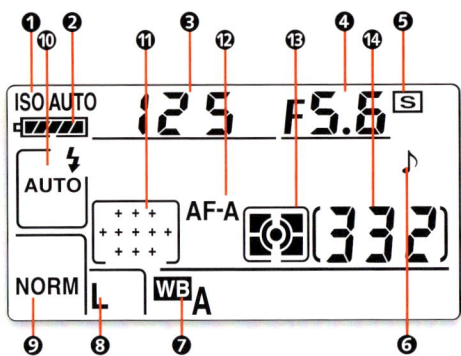

The display in the illustration shows the status for an i-TTL flash shot with maximum image size and "JPEG Normal" image quality. The camera is set to use matrix metering, automatic white balance, and Auto Select (AF-A) autofocus in Auto-area AF-area mode.

Control Panel Indicators			Control Panel Indicators		
#	Symbol	Description	#	Symbol	Description
❶	ISO	ISO sensitivity indicator	❹	F3.5	Aperture (f-number)
	ISO AUTO	ISO AUTO indicator		0.7	Bracketing increment
❷	🔋	Battery power indicator		PC	PC connection indicator
❸	250	Exposure time (shutter speed)	❺	S / ⊒	Shooting mode
	+0.3	Exposure compensation / Flash compensation value	❻	♪	"Beep" indicator
	100	Sensitivity	❼	WB A ☀ 🌥 ☁ ⚡ 🌊 🏠 K PRE	White Balance mode
	+1	White balance fine-tuning			
	3000	Color temperature	❽	L M S	Image size
	3F	Number of shots in bracketing sequence	❾	RAW+ FINE NORM BASIC	Image quality

The Control Panel Display

Control Panel Indicators		
#	Symbol	Description
⑩	AUTO SLOW REAR	Flash sync mode
⑪	(focus area symbol)	Active focus area / AF-area mode
⑫	AF-A AF-S AF-C	Autofocus mode
⑬	(metering symbol)	Metering mode

Control Panel Indicators		
#	Symbol	Description
⑭	[108]	Number of exposures remaining (free memory card capacity)
	[r 10]	Number of shots remaining before memory buffer fills
	PC	PC mode indicator
	PrE	Preset white balance recording indicator

Additional Display Elements

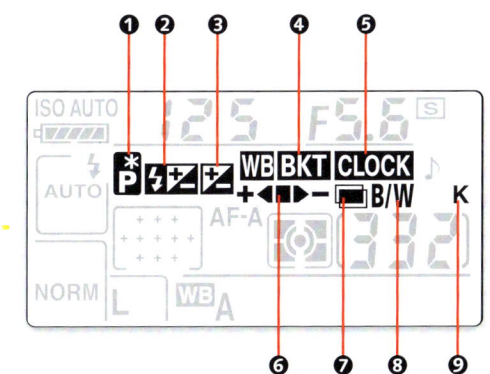

Control Panel Indicators		
#	Symbol	Description
❶	P*	Flexible program indicator
❷	⚡±	Flash compensation indicator
❸	±	Exposure compensation indicator
❹	BKT	Bracketing indicator
	WB BKT	White balance bracketing indicator

Control Panel Indicators		
#	Symbol	Description
❺	CLOCK	"Clock not set" indicator
❻	+◀▶−	Bracketing progress indicator
❼	▭	Multiple exposure indicator
❽	B/W	Black-and-white indicator
❾	K	Memory remains for more than 1000 shots

The Viewfinder Display

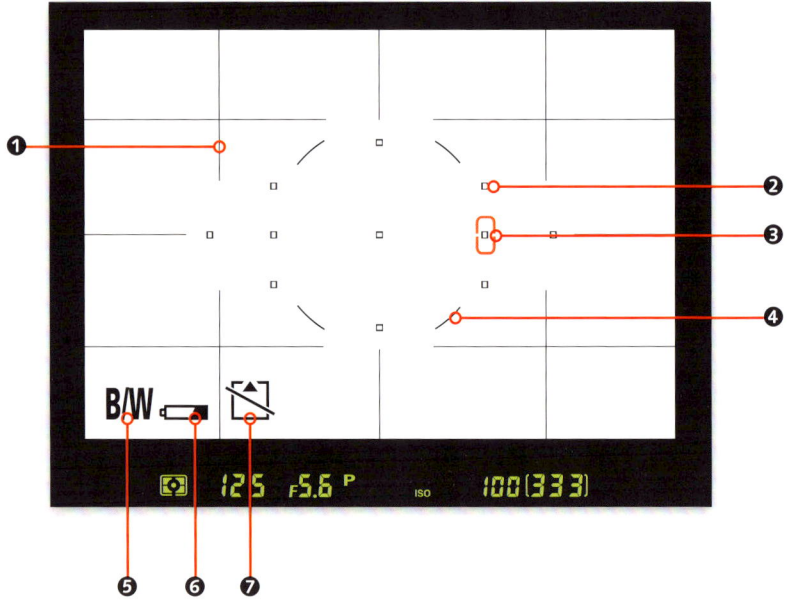

#	Symbol	Description
❶		Framing grid (displayed only when custom setting d2 is set to "On")
❷	▫	Focus area markings (also for spot and wide-frame metering)
❸	⊂▫⊃	Active focus area brackets
❹		8-mm (0.31-inch) reference circle for center-weighted metering
❺	B/W	Black and white mode*
❻	▭	Battery life*
❼	🅇	"No memory card" warning*

* These indicators can be hidden using **custom setting 9**

The Viewfinder Display

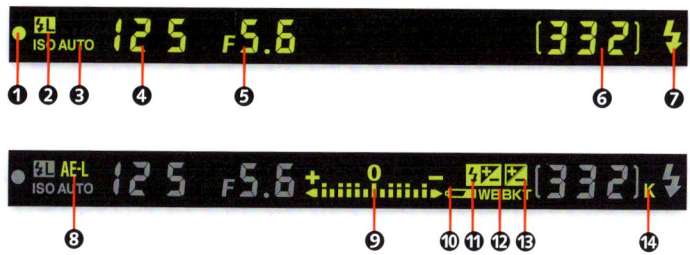

#	Symbol	Description
❶	●	Focus indicator
❷	🔆L	Flash value (FV) lock
❸	ISO AUTO	Auto ISO sensitivity indicator
❹	125	Exposure time (shutter speed)
❺	F5.6	Aperture
❻	[333]	Number of exposures remaining (memory card capacity)
	[r 20]	Number of Shots remaining before memory buffer fills
	PrE	Preset white balance recording indicator
	0.3	Exposure compensation/Flash compensation value
	PC	PC connection indicator
❼	🔆	Flash-ready indicator
❽	AE-L	Autoexposure (AE) lock
❾	+ıııııı0ıııııı-	Electronic analog exposure display
		Exposure compensation
❿	⬛	Battery life indicator
⓫	🔆±	Flash compensation indicator
⓬	WBBKT	Bracketing indicator
⓭	±	Exposure compensation indicator
⓮	K	Memory for more than 1000 shots remains

The D80's Menu Structure

This section includes a complete overview of the D80's menu structure. The tables below use the following coding system:

Options printed in **bold** are default settings.
Options printed in blue activate a submenu.

The D80's **menu system** is controlled via five main menus

The Playback Menu ▶

This menu contains all the settings relating to the viewing of images on the camera monitor. The "Delete" function can also be activated directly using the delete button.

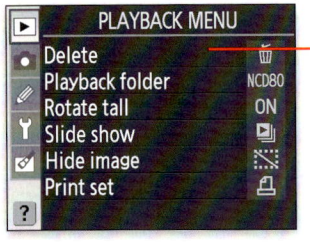

The 🗑 button deletes the currently displayed image

▶ Playback Menu

Menu Item	Option	Details
Delete	Selected	Deletes only the images selected individually by the photographer
	All	Deletes all images
Playback Folder	**Current**	Displays only the images in the folder currently selected for "Folders" in the shooting menu
	All	Displays all images in all folders on the memory card
Rotate Tall	**On**	Images shot with the "Auto Image Rotation" option switched to "On" are displayed in vertical format (2/3 height) during playback
	Off	Images shot in tall format are not automatically rotated and are shown in horizontal format during playback
Slide Show	Start	Starts the slide show
	Select pictures	Opens a dialog with thumbnail images for selection
	Change settings	Displays a submenu with a choice of slide show display styles. "Standard" allows you to select the interval between photos; "PictMotion" allows you to select background music.
Hide Image	Select/Set	Hide or reveal selected images
	Deselect all?	Reveals all photos
Print Set	Select/set	Displays thumbnails for selection of photos for printing on a PictBridge printer or DPOF-compatible device
	Deselect all?	Removes all photos from the current print order

The Shooting Menu 📷

This menu contains all the functions relevant to actually taking pictures. Some of the functions (such as image size and quality, or ISO sensitivity) can be activated directly using the camera's buttons. The highlighted settings are our recommendation for an efficient standard setup.

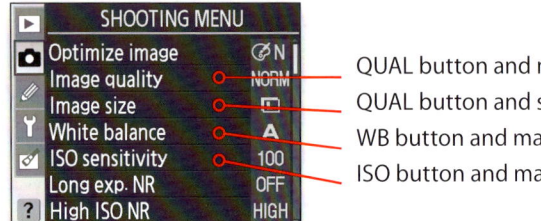

QUAL button and main command dial
QUAL button and sub-command dial
WB button and main command dial
ISO button and main command dial

	📷 Shooting Menu	
Menu Item	**Option**	**Details**
Optimize Image	**Normal**	Recommended for most situations
	Softer	Softens outlines, producing natural results suitable for portraits or retouching on a computer
	Vivid	Enhances saturation, contrast, and sharpness to produce images with vibrant colors
	More vivid	Maximizes saturation, contrast, and sharpness to produce crisp images with sharp outlines
	Portrait	Lowers contrast for natural skin tones
	Custom (see gray table below)	Custom options available in a submenu. Color space can here be set to Adobe RGB.
	Black and white	For black and white photos ("Standard"), or with color filter effects ("Custom")
Image Quality	**NEF (RAW)**	RAW file with 12-bit color depth
	JPEG Fine	Very high image quality, compression ratio approx. 1:4
	JPEG Normal	Normal image quality, compression ratio approx. 1:8
	JPEG Basic	Lower image quality, compression ratio approx. 1:16
	NEF (RAW) +JPEG Fine	RAW file with 12-bit color depth and an additional second version in JPEG Fine quality
	NEF (RAW) +JPEG Normal	RAW file with 12-bit color depth and an additional second version in JPEG Normal quality
	NEF (RAW) +JPEG Basic	RAW file with 12-bit color depth and an additional second version in JPEG Basic quality

📷 Shooting Menu

Menu Item	Option	Details
Image Size	**L 3,872 x 2,592 (10.0 MB)**	Full-size images
	M 2,896 x 1,944 (5.6 MB)	Reduced-size images, not possible in combination with RAW images
	S 1,936 x 1,296 (2.5 MB)	
White Balance (only in P, S, A, and M modes)	Auto	The camera calculates the optimum white balance value automatically
	Incandescent	Use under incandescent lighting
	Fluorescent	Use under fluorescent lighting
	Direct sunlight	Use with subjects lit by direct sunlight
	Flash	Use with built-in Flash or optional Nikon accessory flash units
	Cloudy	Use in daylight, under overcast skies
	Shade	Use in daylight, for subjects in the shade
	Choose color temp.	Color temperature can be individually selected form a list of values
	White balance preset	Color temperature is determined using a gray or white reference object, or an existing photo
ISO Sensitivity	ISO Auto	Sensitivity is increased automatically as required (default setting in Auto and Digital Vari-Program modes)
	100 13 values between 100 and 1600 plus H 0.3; H 0.7; H 1.0	Sensitivity can be set to values between ISO 100 and 1600 in steps of 1/3 EV. Where high sensitivity is a priority, this value can be further increased in three steps up to 1 EV above ISO 1600. (ISO 100 is the default setting in P, S, A, and M modes).
Long Exposure Noise Reduction	**Off** On	Noise reduction can be turned on or off; when turned on, is used only for shutter speeds of 8 seconds and slower
High ISO Noise Reduction	**Normal** Low High Off	Noise reduction is activated at ISO sensitivities of 400 or above. There is a choice of three levels. Noise reduction is turned off for ISO values of 800 and below. Minimal NR is performed at sensitivities above 800.
Multiple Exposure (only in P, S, A, and M modes)	OK	Activates a multiple exposure using the settings selected for the other two options
	Number of shots	Selects the number of shots that make up the multiple exposure (2 or 3)
	Auto gain	Gain is adjusted automatically to the number of shots selected, provided the "On" option is selected in the function's submenu. Gain is not adjusted automatically if the "Off" option is selected.

The "Custom" Submenu in the "Optimize Image" Menu

This submenu contains all the image optimization functions that can be applied to your NEF images later using Nikon Capture NX. Our recommendations for consistently good images are highlighted in yellow. The highlighted settings are especially appropriate if you want to shoot JPEG images for subsequent processing on a computer.

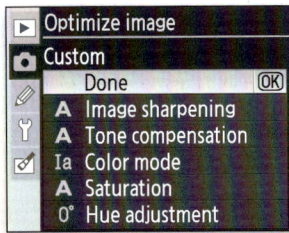 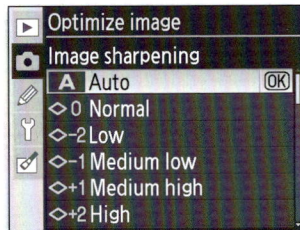

Shooting Menu > Optimize Image > Custom		
Menu item	Option	Details
Done	OK	Confirms settings and returns to shooting menu
Image Sharpening	**Auto**	Default setting; adjusts sharpening according to subject
	0 Normal	All images are sharpened by the same standard amount
	-2 Low	Images sharpened significantly less than the standard amount
	-1 Medium low	Images sharpened slightly less than the standard amount
	+1 Medium high	Images sharpened slightly more than the standard amount
	+2 High	Images sharpened significantly more than the standard amount
	None	Image sharpening is deactivated

\u0000 Shooting Menu > Optimize Image > Custom		
Menu item	Option	Details
Tone Compensation	**Auto**	Camera automatically chooses the appropriate gradation curve
	0 Normal	Camera uses the standard curve for all shots; suitable for most subjects
	-2 Less contrast	For high-contrast subjects; prevents highlights in portraits from being "washed out" in direct sunlight, for example
	-1 Medium low	Contrast slightly reduced
	+1 Medium high	Contrast slightly increased
	+2 More contrast	Increases contrast and preserves detail (e.g., for misty landscapes)
	Custom	Custom curve can be created in Nikon Capture NX and uploaded to the camera
Color Mode	**Ia (sRGB)**	sRGB color space, optimized for portraits
	II (Adobe RGB)	Larger color space, especially suitable for images that are going to be retouched later
	IIIa (sRGB)	sRGB color space, optimized for landscape shots
Saturation	**0 Normal**	Normal saturation; recommended for most situations
	- Moderate	Reduced saturation; recommended for pictures that will be retouched later on a computer
	+ Enhanced	Increased saturation; use for printing effects for pictures that will be directly printed without further modification
Hue Adjustment	−9° to +9° **0°**	Allows a fine adjustment of color in steps of 3° from the chosen angle within the color circle

The Custom Setting Menu

Custom settings allow you to set up the camera's basic functions according to your own personal preferences. The menu itself is available in two versions: Simple and Full, with the Simple version containing only the first 10 Custom settings. The Simple and Full views can be selected using the option "CSM/Setup menu" in the Setup Menu.

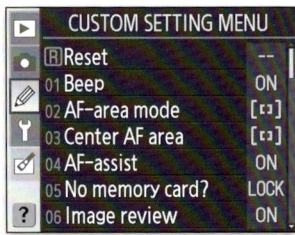

Custom Setting Menu		
Menu Item	**Option**	**Details**
R Reset	**No**	Returns to the custom setting menu without changing any settings
	Yes	Restores all custom settings to their default values
1 Beep	**On**	Beep sounds when single-servo autofocus has focused successfully, or when the release timer is counting down in self-timer and delayed remote modes
	Off	Beep does not sound
2 AF-Area Mode	Single-Area	Focus area selected manually by user; camera focuses on subject in selected focus area only
	Dynamic-Area	User selects focus area manually. If subject leaves this focus area, even briefly, camera will focus based on info from other focus areas and adjusts focus accordingly
	Auto-Area AF	Camera selects focus area automatically
3 Center AF Area (all modes)	**Normal Zone**	Camera focuses on a specific subject within a small area without nearby objects interfering with focus
	Wide Zone	Camera focuses within a larger area, in order to focus on moving subjects and other objects which are difficult to track (this setting is not available when **custom setting 2** is set to "Auto-Area AF")

🖉 Custom Setting Menu

Menu Item	Option	Details
4 AF-Assist (all modes except 🖼, 🏃, and 🎦)	**On**	AF-assist illuminator switches on automatically if subject is poorly lit (only in single-servo AF mode)
	Off	AF-assist illuminator switched off
5 No Memory Card?	**Release Locked**	Shutter release is disabled when no memory card is inserted
	Enable release	Shutter release is enabled, even if no memory card is inserted; images shot are displayed on the monitor, but are not saved
6 Image Review	**On**	Images are automatically displayed on the monitor for about 4 seconds immediately after shooting
	Off	Images are displayed on the monitor only if the ▶ button is pressed
7 ISO Auto (only in P, S, A, and M modes)	**Off**	ISO sensitivity remains fixed at the value selected with the ISO button
	On	ISO sensitivity is automatically adjusted if optimum exposure can not be achieved using the selected value; a maximum value can be selected in the function's submenu
8 Grid Display	**Off**	No grid lines are displayed in the viewfinder
	On	Grid lines are displayed in the viewfinder to assist framing
9 Viewfinder Warning	**On**	Warning symbols are displayed for black-and-white mode, too little battery power, or when no memory card is inserted
	Off	No warnings are displayed
10 EV Step	**1/3 EV**	Used to select whether adjustments to shutter speed, aperture, and bracketing are made in increments of 1/3 or 1/2 EV
	1/2 EV	
11 Exposure Compensation (only in P, S, A, and M modes)	**Off**	Exposure compensation is set using the 🔲 button and the main command dial
	On	Exposure compensation is set using one of the command dials only (which dial depends on the current setting for **custom setting 15**, "Command Dials")
12 Center-Weighted (only in P, S, A, and M modes)	ø 6 mm **ø 8 mm** ø 10 mm	Controls the size of the area in the center of the viewfinder assigned the greatest weight when using center-weighted metering

Custom Setting Menu

Menu Item	Option	Details
13 Auto BKT Set (only in P, S, A, and M modes)	**AE & Flash**	Camera varies flash level and exposure with each shot
	AE Only	Camera varies exposure with each shot
	Flash Only	Camera varies flash level with each shot
	WB Bracketing	Only white balance is varied; camera saves multiple copies of one image
14 Auto BKT Order (only in P, S, A, and M modes)	**Default Order**	Shot order for bracketing sequences: unmodified > positive correction > negative correction
	Under > Meter > Over	Shot order for bracketing sequences: negative correction > unmodified > positive correction >
15 Command Dials (only in P, S, A, and M modes)	**Default**	Main command dial controls shutter speeds; sub-command dial controls aperture
	Reversed	Main command dial controls aperture; sub-command dial controls shutter speed
16 FUNC. Button	**ISO Display**	Modified ISO sensitivity value is displayed while FUNC. button is pressed
	Framing Grid	Press FUNC. button and rotate the main command dial to turn the viewfinder framing grid on and off
	AF-area Mode	FUNC. button and main command dial select AF area mode
	Center AF Area	FUNC. button and main command dial used to choose between normal and Wide center AF areas
	FV Lock	FUNC. button locks current flash value; pressing FUNC. button again cancels locked value
	Flash Off	Built-in and accessory flash switch off while FUNC. button is pressed
	Matrix Metering	Matrix metering is activated while FUNC. button is pressed
	Center-Weighted	Center-weighted metering is activated while FUNC. button is pressed
	Spot Metering	Spot metering is activated while FUNC. button is pressed
17 Illumination	**Off**	Control Panel backlight can only be turned on by rotating the power switch
	On	Control Panel backlight remains on as long as the exposure meters are active

🖉 Custom Setting Menu

Menu Item	Option	Details
18 AE-L/AF-L	**AE/AF Lock**	Focus and exposure lock while the AE-L/AF-L button is pressed
	AE Lock Only	AE-L/AF-L button locks exposure only
	AF Lock	AE-L/AF-L button locks focus only
	AE Lock Hold	AE-L/AF-L button locks exposure, which remains locked until the button is pressed again or the exposure meters turn off
	AF-ON	AE-L/AF-L button initiates autofocus; shutter release cannot be used to focus
	FV Lock	AE-L/AF-L button locks flash value for built-in or accessory flash until button is pressed again or exposure meters are turned off
	Focus Area Selection	Press AE-L/AF-L button and rotate sub-command dial to select focus area
	AE-L/AF-L/ AF Area	AE-L/AF-L button locks exposure and focus, pressing AE-L/AF-L button and rotating sub-command selects focus area
	AE-L/ AF Area	AE-L/AF-L button locks exposure, pressing AE-L/AF-L button and rotating the sub-command dial selects focus area
	AF-L/ AF Area	AE-L/AF-L button locks focus, pressing AE-L/AF-L button and rotating sub-command dial selects focus area
	AF-ON/ AF Area	AE-L/AF-L button initiates autofocus, pressing the button and rotating the sub-command dial selects focus area
19 AE Lock	**Off**	Pressing the shutter release halfway does not lock exposure
	On	Pressing the shutter release halfway locks exposure
20 Focus Area	**No Wrap**	Focus area display is bounded by the outer focus area; pressing multi-selector up, for example, has no further effect
	Wrap	Allows focus area selection to "wrap around" from top to bottom, left to right, and vice versa
21 AF Area Illumination	**Auto**	Active focus area is highlighted red as necessary to establish contrast with the image background
	Off	Active focus is not highlighted
	On	Active focus area is highlighted red (independent of background brightness) as soon as it is selected or autofocus is activated

Custom Setting Menu

Menu Item	Option	Details
22 Built-In Flash (only in P, S, A, and M modes)	TTL	Flash output is adjusted automatically according to shooting conditions
	Manual	Flash fires at the level selected in a submenu without using monitor pre-flash
	Repeating Flash	Flash fires repeatedly while the shutter is open; output, number of flashes, and flash frequency can be selected in a submenu
	Commander Mode	Settings for wireless flash photography with one or more external flash units and using the built-in flash as commander; settings for "TTL", "AA", "M", and for two separate flash groups can be made in a submenu
23 Flash Warning (only in P, S, A, and M modes)	On	If lighting is poor and flash is required, the viewfinder flash-ready symbol will flicker when the shutter release is pressed halfway
	Off	No flash warning is displayed, even if lighting is poor
24 Flash Shutter Speed (only in P, S, A, and M modes)	Between **1/60** and 30 seconds in 12 steps	Selects the slowest shutter speed at which flash will be used in P and A modes: regardless of the setting chosen, flash will fire at shutter speeds as slow as 30 seconds if slow sync is selected
25 Auto FP (only in P, S, A, and M modes)	On	Activates Auto FP high-speed sync for accessory flash at shutter speeds faster than 1/200 second
	Off	Auto FP high-speed sync deactivated
26 Modeling Flash	Off	No modeling flash is emitted
	On	Built-in and accessory flash units (SB-600, SB-800, and SB-R200) emit modeling flash when the depth-of-field preview button is pressed
27 Monitor-Off	5 s 10 s **20 s** 1 min. 5 min. 10 min.	Determines how long the monitor remains switched on when no operations are performed
28 Auto Meter-Off	4 s **6 s** 8 s 16 s 30 s 30 min.	Determines how long the camera continues to meter exposure when no operations are performed

📝 Custom Setting Menu

Menu Item	Option	Details
29 Self-Timer	2 s 5 s **10 s** 20 s	Determines the length of shutter release delay in self-timer mode
30 Remote On Duration	**1 min.** 5 min. 10 min. 15 min.	Determines how long the camera will wait for a signal from a remote trigger before cancelling delayed or quick-response remote modes
31 Exp. Delay mode	**Off**	Mirror is raised and exposure is made immediately on pressing the shutter release
	On	Shutter release is delayed approx. 0.4 seconds after pressing the shutter-release button, reducing camera shake in critical situations
32 MB-D80 Batteries	**LR6** **(AA Alkaline)** HR6 (AA Ni-MH) FR6 (AA Lithium) ZR6 (AA Ni-Mn)	Used to select battery type and ensure correct camera operation when using the optional MB-D80 battery pack; there is no need to adjust this option when using EN-EL3e batteries

The Setup Menu 🔧

The setup menu governs the preset values for most of the camera's basic functions.

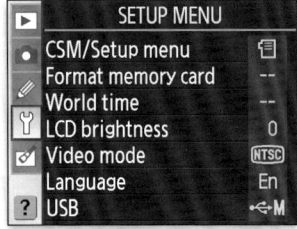

		🔧 Setup Menu
Menu Item	**Option**	**Details**
CSM/Setup Menu	Simple	Displays only basic options in the custom settings and setup menus
	Full	Displays all options in all menus
	My Menu	Displays only user-selected options in playback, shooting, custom settings, and retouch menus
Format Memory Card	No	The memory card will not be formatted
	Yes	The memory card is formatted following a security dialog; all images (including hidden and protected images) are deleted
World Time	Time Zone	Selects the appropriate time zone; clock is automatically adjusted accordingly
	Date	Sets the camera clock (date and time)
	Date Format	Selects the order in which month, day, and year are displayed
	Daylight Saving Time	Camera clock is automatically adjusted for daylight saving time
LCD Brightness	+2 to -2	Adjusts monitor brightness between -2 (darker) and +2 (brighter)
Video Mode	NTSC	Sets the camera to function with NTSC standard video devices (the usual standard in the USA)
	PAL	Sets the camera to function with PAL standard video devices (the usual standard in Europe)

Setup Menu

Menu Item	Option	Details
Language	(List of 15 languages)	Selects the desired language for the camera's menus and messages
USB	**Mass Storage**	Standard USB protocol, supported by most conventional operating systems
	PTP	USB protocol for printing using PictBridge printer and for controlling the camera remotely using Camera Control Pro; can also be used in Windows XP and Mac OS X for data transfer between the camera and PictureProject or Capture NX
Image Comment	Done	Saves changes and returns to the setup menu
	Input Comment	Enables comment input using the letters provided in a special submenu
	Attach Comment	The same comment is added to all subsequent photos as long as this option remains checked
Folders	Select Folder	Choose the existing folder in which subsequent photos will be stored
	New	Creates a new folder, which can be named using up to 5 characters
	Rename	Select a folder from a list and rename it
	Delete	Deletes empty folders following a security dialog
File No. Sequence	**Off**	File numbering is reset to 0001 when a new folder is created, the memory card is formatted, or a new memory card is inserted
	On	File numbering continues from the last number used after a new folder is created, the memory card is formatted, or a new memory card in inserted; if a photo is taken when the current folder already contains a photo with the number 9999, a new folder will be created and file numbering will begin again from 0001
	Reset	Same as "On", except that file numbering is reset to 0001 with the next photo taken

Setup Menu

Menu Item	Option	Details
Mirror Lock-Up	On	Locks the mirror in the up position when inspecting or cleaning the low-pass filter that protects the camera Image sensor
	Off	Deactivates mirror lock-up
Dust Off Ref Photo	On	Enables you to take a reference photo for use with the Dust Off feature in Capture NX
	Off	Cancels the feature and returns to the setup menu
Battery Info	Bat. Meter	Current battery level as a percentage of full charge
	Pic. Meter	Number of times the shutter has been released since the battery was last charged
	Charge Life	Five-level display showing battery age from 0 (new) to 4 (requires replacing)
Firmware Version		Displays the current firmware version number
Auto Image Rotation	**On**	Saves image orientation info together with the image data
	Off	No image orientation data saved

The Retouch Menu

The functions included in the retouch menu can be used to optimize your images directly in the camera if, for example, you want to print your images directly without using a computer.

Retouch Menu		
Menu Item	**Option**	**Details**
D-Lighting		Saves an additional image copy with brightened shadow areas, thus improving photos that are too dark or were taken with backlight. Three different levels of correction available.
Red-Eye Correction		Corrects the red-eye effects often present in flash photos and saves the results in a new image copy
Trim		Saves a cropped image detail in a separate Image copy
Monochrome	Black-and-White	Saves a monochrome image copy
	Sepia	Saves a sepia-toned monochrome image copy with a user-selected level of color saturation
	Cyanotype	Saves a blue-toned monochrome Image copy with a user-selected level of color saturation
Filter Effects	Skylight	Saves an image copy with reduced blue tones (effect like using a normal skylight filter)
	Warm Filter	Creates an image copy with a "warm" reddish cast
	Color Balance	Green, red, blue, and magenta tones can be increased individually using the multi-selector. Color histograms and an image preview in the monitor illustrate the adjusted distribution of tonal values.
Small Picture	Select Picture	Opens a dialog with a thumbnail overview for selecting images to be saved at a lower resolution
	Choose Size	Enables a choice of sizes for small pictures (640 × 480, 320 × 240, or 160 × 120 pixels)
Image Overlay		Two RAW files can be superimposed to make a single final image. Gain (transparency) can be individually adjusted for each of the two images.

The PictBridge Menus

The PictBridge menus can only be accessed if the camera is attached to a PIctBridge-compatible printer using a USB cable.

PictBridge "PictBridge" Menu (access with MENU button)	
Menu Item	Details
Print Set	Opens a dialog with thumbnails for selection of images to be printed
Print (DPOF)	If a print order has been created using the menu item "Print Set", this option can be used to start printing
Index Print	Creates an index print of all JPEG images (maximum 256) in the current folder

PictBridge "Settings" Menu (access with OK button)	
Menu Item	Details
Start Printing	Prints currently selected picture(s)
Page Size	Offers a choice of paper formats supported by the currently connected printer; "Printer Default" selects the printer's standard format
No. of Copies	Enables you to choose the number of copies of each image to be printed (maximum 99)
Border	Offers a choice of printing pictures with or without a white border; "Printer Default" selects the printer's standard setting
Time Stamp	If the "Print Time Stamp" option is selected, date and time of the exposure will be printed with the image; "Printer Default" selects the printer's standard setting
Cropping	If the "Crop" option is selected, the size of the image border to be cropped during printing can be selected using the playback zoom and thumbnail buttons

The D80's Exposure Control Modes

Exposure Control Using P, S, A, and M Modes

The D80's exposure modes give the photographer differing degrees of control over aperture and shutter speed. Programmed Auto (**P**), Aperture-Priority Auto (**A**), and Shutter-Priority Auto (**S**) help keep you "quick-on-the-draw" by selecting aperture and/or shutter speed automatically, although the camera's automatic selections can also be selectively adjusted should you wish to selectively influence the final result.

Exposure Modes	
Mode	**Details**
Programmed Auto **P**	Calculates aperture and exposure time automatically, and **determines a combination** of these two factors to give a optimal balance between depth of field and motion freeze for the situation at hand. The **Flexible Program** function can be used to select an alternative combination, allowing the photographer to selectively influence depth of field and motion effects. **Exposure compensation** can be used to apply deliberate over- or underexposure to an image.
Shutter-Priority Auto **S**	Calculates the appropriate aperture setting for a manually-selected exposure time, enabling you to selectively influence the degree of sharpness or motion blur when shooting moving subjects.
Aperture-Priority Auto **A**	Calculates the appropriate exposure time for a manually selected aperture. Small apertures produce greater depth of field; larger apertures can be used to reduce depth of field and to produce different spacial effects.
Manual **M**	Aperture and exposure time are selected manually. The "**bulb**" setting enables you to make long exposures without time limits.

Auto Mode 📷 and the Digital Vari-Programs 💃, 🏔, 🌷, 🏃, 🌃, 👤

As well as its universal Auto mode, the D80 offers a number of additional point-and-shoot modes ("Digital Vari-Programs"), which are specially tailored to shooting specific subjects and/or situations. These modes preselect and lock some camera settings (such as aperture and exposure time) while others (such as autofocus mode, AF-area mode, or flash mode) are preset, but can be adjusted by the photographer. The table lists the most important standard presets for each mode.

Digital Vari-Programs	
Mode	**Details**
Auto 📷	Selects an automatic combination of aperture and exposure time, in order to ensure an optimal balance between depth of field and subject sharpness. Presets auto-area AF mode, auto select (AF-A) autofocus mode and i-TTL flash mode. Ideal for snapshots.
Portrait 💃	Sets a wide aperture to separate the subject from the background. optimizes contrast, sharpness, and color (green and blue tones). Presets auto-area AF mode, AF-A autofocus mode, and i-TTL flash mode.
Landscape 🏔	Sets a relatively small aperture in order to produce as much depth of field as possible. Presets auto-area AF mode and AF-A autofocus mode. Flash is deactivated, and colors are automatically optimized.
Closeup 🌷	Sets a medium aperture (f8 or f5.6). Presets single-area AF mode, AF-A autofocus mode, i-TTL flash mode, and more saturated colors (red and green tones).
Sports 🏃	Uses short exposure times to freeze the movement of dynamic subjects. Presets auto-area AF mode, AF-A autofocus mode, and deactivates flash.
Night Landscape 🌃	Uses wide apertures and relatively short exposure times, but nevertheless requires the use of a tripod. Presets auto-area AF mode, AF-A autofocus mode, and deactivates flash.
Night Portrait 👤	Selects a wide aperture. Maximum exposure time is 1 second. Uses i-TTL flash with slow sync to ensure balanced exposure of foreground and background. Presets auto-area AF mode and AF-A autofocus mode.

Installing Adobe Reader

Your Nikon D80 **Dbook** is an interactive book published in Acrobat (PDF) format. Although many programs exist for opening and viewing PDF files, only Adobe Reader and Adobe Acrobat (version 7.0 and higher) fully support your **Dbook**'s interactive functionality. If you do not own either of these programs, you can install Adobe Reader 8 from the **Dbook** CD.

Your **Dbook** is designed to be displayed using Adobe Reader (or Acrobat) 7 and 8, and uses features that are not supported by older versions. If you open your **Dbook** using an older version of the program, it is possible that some of the interactive features won't function correctly, and that the illustrations will not be shown at their best quality.

The same is true for other PDF reader products such as Apple Preview, which is built in to the Mac OS X operating system. Preview does not support the interactive **Dbook** features. We strongly recommend that you only use Adobe Reader (or Acrobat), and only in the latest version. Adobe Reader 8 is included on the **Dbook** CD (in Windows and Mac versions). You will find an installation guide for the reader in the "Adobe Reader" folder on the CD. Simply open the "ReadMe.html" file in the web browser of your choice and follow the instructions listed.

Your **Dbook** is also designed for a specific display size that cannot be maintained if the application settings are incorrect. Erroneous settings can also result in the **Dbook** toolbar being partially or completely hidden, and in malfunctioning interactive features.

Please take a moment to make the necessary settings, and thus maximize your **Dbook** experience. The tables on the following page detail all the settings you should make in the Adobe application's "Preferences" dialog. A more detailed description of the how and why of these settings can be found in the "Displaying Your Dbook" chapter in the **Dbook** itself.

Adobe Reader 8 "Preferences"		
Category	**Option**	**Setting**
Documents	Restore last view settings when reopening documents	Activate
Page Display	Custom resolution	72 pixels/inch
	Smooth text	"For monitor"
	Smooth line art & Smooth images	Activate
Full Screen	Fill screen with one page at a time	Deactivate
	Alert when document requests full screen	Deactivate
	Left click to go forward one page, right click to go back one page	Deactivate
	Background color	Black
Forms	Show focus rectangle	Deactivate
	Always hide forms document message bar	Activate

Adobe Reader 7 "Preferences"		
Category	**Option**	**Setting**
Forms	Show focus rectangle	Deaktiviert
Startup	Reopen documents to last page viewed	Alle Dateien
Page Display	Smooth text, Smooth line art, Smooth images	Activate
	Custom resolution	72 pixels/inch
Full Screen	Left click to go forward one page, right click to go back one page	Deactivate
	Background color	Black